The Drawing Center
January 25–February 28, 2014
Drawing Room

Deborah Grant
Christ You Know it Ain't Easy!!

Curated by
Claire Gilman

DRAWING PAPERS 111

Introduction *by* Claire Gilman
Essay *by* Theresa Leininger-Miller

Introduction

Claire Gilman

I first met Deborah Grant in 2001, on the occasion of *Freestyle*, the landmark exhibition at The Studio Museum in Harlem in which she participated and for which I wrote a catalogue essay. Following her career since then, I have been impressed with her consistent dedication, her intelligence, and with the sense of purpose with which she has pursued her work. It has been a pleasure to collaborate with Deborah on a project developed specifically for The Drawing Center. *Christ You Know it Ain't Easy!!* was three years in the making and it is her most ambitious undertaking to date. I am thrilled to present this extraordinary project—Grant's first solo show in a museum in New York—to the viewing public.

Christ You Know it Ain't Easy!! is the latest installment in Grant's ongoing series *Random Select*, in which she interweaves historical accounts and personal experiences with references to contemporary political and social issues. Grant culls material from a variety of sources, including magazine photographs, comic books, and published texts, which she then masterfully assembles together on birch panels via a signature drawing method involving silhouetted figures and calligraphic marks and lines. For The Drawing Center, Grant has produced a large four-panel piece (*Crowning the Lion and the Lamb*), as well as twenty-four smaller birch panels (*God's Voice in the Midnight Hours*), two shaped panels (*Obedient Unto Death, Even Death on a Cross* and *Hosanna to the Son Of David*) and a series of five drawings (*Easter's Best*). The subject (which is dealt with explicitly in *Crowning the Lion and the Lamb* and obliquely in the side panels) concerns the fictional meeting between African American folk artist Mary A. Bell (1873–1941) and renowned modernist painter Henri Matisse (1869–1954).

Bell was a deeply devout Catholic maid who never received formal artistic training but who produced over a hundred drawings after she had retired from service. She believed herself to be an instrument of God, and her crayon and colored-pencil renderings, which frequently depict fanciful scenes of well-dressed white couples, but which also include portraits of Creole ladies and other outsider types, were collected by significant cultural figures such as Gertrude Stein, the art critic Henry McBride, the writer and photographer Carl Van Vechten, and artists Florine Stettheimer and Gaston Lachaise (Bell worked for the sister of Lachaise's wife). Troubled for many years by mental illness, Bell was committed to a mental health facility in Boston in 1940, where she died from heart failure the next year.

In Grant's telling, Bell encounters Matisse in a dream after falling asleep while working late one night on her drawings. The modern master appears at the foot of her bed discoursing on his famous large-scale paper collages, which he calls "painting with scissors." After a brief discussion about abstract art and her own personal history, Bell wakes up only to realize that she is in the Boston State Hospital. In the installation's central four-panel piece, Grant evokes this scene with imagery from Bell's bedroom. The side panels and drawings focus on the guiding theme of Bell's life, religious faith, while simultaneously incorporating references to her own and Matisse's art. Through a series of vignettes, the panels re-imagine this subject across space and time in which characters from Grant's personal history (including the artist herself, who is pictured as a young school girl walking with a neighborhood rabbi), as well as figures from popular novels and films, assume alternate identities.

What have Bell and Matisse to do with each other? Why this focus on religion? How does an examination of the relationship between Jewish and Christian symbols (the subject of the shaped panels), or a portrait of a homeless man turned angel from Milton's Paradise Lost (one of the twenty-four birch panels), relate to the central scene? Anyone seeking direct answers is sure to be frustrated. Indeed, Bell's life situation remains miles apart from that of the modern master. And yet Grant's purpose in bringing these distinct worlds together is less to forge previously undiscovered connections than to reveal the

instability and heterogeneity that infects even the most seemingly stable doctrines, such as those associated with modernist painting or that provide the foundations of Catholic faith.

Recognizing Matisse's ubiquitous palm form atop planters decorated with Christian and Jewish motifs, or his dancer become the Angel Gabriel in a Byzantine-influenced scene from *God's Voice in the Midnight Hours*, one may begin to understand the way in which these diverse and indeed opposing artistic styles come together. Considering Matisse's abstracted forms alongside Bell's folk motifs alongside iconography from centuries of religious art and culture demonstrates how all of these images are products of their own kinds of faith—faiths that are subject to revision over time.

The eclectic nature of thought, the way in which different artistic and social traditions intermingle, this is in essence what *Christ You Know it Ain't Easy!!* and *Random Select* are about. Put differently, Grant's concern is less the specific subject at hand than the dreams, passions, and historical memories it elicits. The indecipherable pen marks that bind her images together in the central panels are not mere incidental gestures. Constituting a free association drawing into which one can enter and exit at any point, these marks epitomize the open-ended nature of Grant's project as a whole. Quoting Gertrude Stein, who purchased art from Bell, Grant recently observed: "Art isn't everything, it's just about everything." These words could apply to her own work as well.

I would like to thank Deborah for her industriousness, dedication, and good will throughout this process. It has been a pleasure to get to know Deborah and I am honored to have had this opportunity to work with her in such a close way. I am also indebted to Theresa Leininger-Miller, whose pioneering work on Bell inspired The Drawing Center's collaboration with Deborah and who has authored an essay for this volume.

The Drawing Center's staff provided invaluable assistance in realizing this exhibition. Special thanks to Brett Littman, Executive Director, and especially to Nova Benway, Curatorial Assistant. Thanks also to

Molly Gross, Communications Director; Anna Martin, Registrar; Dan Gillespie, Operations Manager; Nicole Goldberg, Deputy Director, External Affairs; Jonathan T.D. Neil, Executive Editor; Joanna Ahlberg, Managing Editor; and Peter J. Ahlberg/AHL&CO, Designer.

Finally, I am incredibly appreciative of the steadfast support of The Drawing Center's Board of Trustees and the funders who have supported this exhibition and its accompanying publication: Steve Turner and Victoria Dailey, Monroe Denton, Dee and Gianna Kerrison, and Jeanne Greenberg Rohatyn.

Deborah Grant: Christ You Know it Ain't Easy!!

Theresa Leininger-Miller

A "personal Pandora's box of visual material"[1] rewards viewers who pay sustained attention to the extraordinarily detailed drawing, painting, and photographic collages of Deborah Grant. In the current exhibition there are four major works—a large-scale, four-part piece on Baltic birch panel, twenty-four smaller panels, two shaped panels, and five drawings on paper. A highly personal investigation of modernist art, early twentieth-century history, politics, race, religion, and cultural identity tie them together.

Grant's work eludes easy interpretation, offering instead poetic mediations on hundreds of objects, faces, and figures from unrelated sources that she reassembles and juxtaposes in surreal sequences. The result is a beguiling, non-narrative collection of both recognizable and ambiguous icons. The title of the exhibition, *Christ You Know it Ain't Easy!!*, lyrics from the Lennon/McCartney song "The Ballad of John and Yoko" (1969), suggests the patience with which Grant has crafted her dense imagery and the effort one must make to discover the many allusions in it.

CROWNING THE LION AND THE LAMB

Standing back from *Crowning the Lion and the Lamb*, one perceives a large erratic shape crammed with black and white symbols and words in the middle of each of its four upright rectangular panels. These four areas evoke angular land masses on a map in a sea of tiny black

1 Franklin Sirmans, "Deborah Grant," *Freestyle* (New York, NY: Studio Museum in Harlem, 2001), 33. And of course by "Pandora's Box" I—and I take Sirmans to as well—intend that such attention will have only positive widespread consequences.

ciphers. Hugging the borders of each panel are intermittent narrow bands, squares, and irregular triangles in red—flat areas of vivid color that offer syncopated visual relief to the work's density.

In this piece, Grant imagines a meeting between renowned modernist painter Henri Matisse and the virtually unknown, self-taught African American artist Mary A. Bell (1873–1941). Bell worked as a maid for the sister of the wife of sculptor Gaston Lachaise, first in Maine and then, by 1936, in Boston. In her sixties, and working mostly at night, Bell produced crayon and colored pencil drawings of beautiful women, both white and of mixed heritage, on tissue paper (perhaps the kind used for dress making patterns). She drew many courtship scenes that took place in parlors or gardens, and stored the works under her bed. Enchanted by movies, Bell longed to see her images transferred to the silver screen—she believed she was reincarnated and that whispering spirits told her to make herself known to the world. Through the Lachaises, New York writer and photographer Carl Van Vechten became Bell's primary patron, purchasing over a hundred of her drawings for fifty cents per piece and developing a correspondence with her. He also convinced other notables, such as writer and art collector Gertrude Stein, art critic Henry McBride, and the painter Florine Stettheimer, to buy Bell's work. Bell's art remained known only to this small circle. Unmarried and childless, she was committed to a mental health facility in Boston in 1940, dying there from heart failure. Ten days later, she was buried in a pauper's grave.

Grant envisions Bell drawing while listening to Marian Anderson sing on a 1936 Belmont 746 radio. Bell thought of herself as an instrument of God who had two natures, the lion and the lamb. Falling asleep, she dreams about Matisse appearing at the foot of her bed. Introducing himself as "Henri the lamb," Matisse talks with Bell about his famous large paper collages, which he called "paint-ings with scissors," and about abstract art, religion, and Bell's life. Upon awakening, Bell realizes she is in a state hospital.

In Grant's work, there are obvious references to Matisse, such as a drawing of his bust and the words, "MoMA New York 1951

exhibition!" which refer to Alfred Barr Jr.'s selective show of the artist at the Museum of Modern Art that year. We also see images from his art: palm fronds, pigeons, a vase of flowers, a woman's torso, a palette and brushes, and the word "jazz," all in black and white, as well as a wood relief cutout of the figure in his *Icarus* (1943). From Bell's side, Grant interweaves portraits of Van Vechten and Stein, a facsimile of a handwritten, stamped envelope mailed to Van Vechten, the words "Gone with the Wind" (a movie that likely inspired Bell), an image of Bell's diseased heart, and Bell's signature on the cover of *Time* magazine, which is indicative of her desire for fame.[2] Also evident in the composition is Bell's own imagery from drawings she made in the late 1930s, such as heads of women and an oval portrait of the Virgin Mary.

Perhaps most poignant, however, is Grant's interpretation of Bell's bed and nightstand. On the end table sit an Art Deco lamp, a cross, holy water, an American flag, and a clock. On the bed's finial hang a theatrical mask (symbolic of the various identities that Grant believes Bell 'performed') and a stiff tag, like a toe tag for a corpse, with Bell's surname, the word "Boston," and the year "1940," which is when Bell entered the hospital. Above this vignette one reads the words "God is Love," in both English and Hebrew. Twice there appears a large bald profile of a head (once in drawing and once in wood relief) emitting three wavy lines—Is the person vomiting, singing, announcing something, or blowing leaves? Also cryptic are the silhouettes of a writing hand, a dog, a tree—shades of work by Bill Traylor here—and Dada-like references, such as men wearing dunce caps and photographic pictures of people's heads cut from old *Life* magazines with censor bars over their eyes. Such a profusion of details compels the viewer to look closely and to wonder at the possible relationships between the images.[3]

2 In a conversation I conducted with Grant, she explained to me how she imagined that when Bell awoke from her dream, she saw an old copy of *Time*, the October 20, 1930 edition, which did in fact feature Matisse on its cover.

3 A celebrated Abstract Expressionist work inspired Grant's all-over style. Jackson Pollock's *Number 11* (1952), also known as *Blue Poles*, was one of the first paintings Grant saw as a child, and she has explained how she appreciated the way the splatters and complex skeins of enamel and aluminum paint encourage the eye to meander in different directions.

Contrast the jumble of things in the central areas with the carefully ordered columns of Grant's own indecipherable script—thousands of neat rows of abstracted language—in the background of each panel. With elements that appear variously as Hebrew, Arabic, Japanese, Chinese, and Nigerian *nsibidi*, this "spirit writing" takes any clear narrative out of the picture. The meditative and intentional character of the chirography suggests an automatic process, and it echoes similar inscriptions by such self-taught artists as James Hampton, J.B. Murry, and Adolf Wölffli.

Crowning the Lion and the Lamb extends Grant's *Random Select* series, which she began in 1996. Earlier works include equally unlikely pairings of historical figures, such as the Irish-born painter Francis Bacon and African-American comedienne Jackie "Moms" Mabley from her 2009 project *Bacon, Egg, Toast in Lard*. One such painting from 2009 depicts an imagined conversation between Bacon and Mabley in a London pub in 1962. Grant uses the specificity of people who were in reality quite different from each other, to reflect on their commonalities. In the case of Bacon and Mabley, both lived as out gay adults, had traumatically violent youths, and confronted personal demons in and through their creative work.[4] While the biographies of Bell and Matisse converge to a far lesser extent, each shared the love of a vibrant palette, flat areas of color, skewed perspective, and depictions of beautiful women.

GOD'S VOICE IN THE MIDNIGHT HOURS,
HOSANNA TO THE SON OF DAVID,
AND
OBEDIENT UNTO DEATH, EVEN DEATH ON THE CROSS

The twenty-four panel series *God's Voice in the Midnight Hours* contrasts markedly with *Crowning the Lion and the Lamb*. Each of its panels, which are grouped in random order in sets of twelve, are spare; and each features a simple image in flat colors with captions in handwritten letters. The scenes relate to both Christianity and

4 For more information about Grant's work on Bacon and Mabley, see Elizabeth Thomas, Exhibition brochure for *Deborah Grant: Bacon, Egg, Toast in Lard*, MATRIX 228, University of California Berkeley Art Museum and Pacific Film Archive (May-October, 2009), 1. http://www.bampfa.berkeley.edu/exhibition/228. Accessed August, 2013.

Judaism. Of all the ethnicities and cultures that Grant was exposed to growing up on Coney Island in the 1970s, it was a neighbor, a Hassidic rabbi, who fascinated her the most. He owned six magnificent Torahs, which he showed to the neighborhood children, explaining their layout using a ruler like a Yad, a Jewish ritual pointer. And as an adult, Grant realized how unusual this experience was, and she appreciated the man's passion for his religious heritage and his willingness to share it with non-Jews such as herself (Grant was raised Catholic).

Grant told me that she sees common elements in both Jewish and Christian theologies, and her parallel treatment of religious objects and symbols signifies her respect for the ritual aspects of both religions. For example, in two birch pieces that take the shape of flame-like potted palms (Matisse's forms), Grant features sacred items arranged symmetrically on the exteriors of bulbous vessels. In *Hosanna to the Son of David*, from top to bottom, we see a Yad, two pink blossoms, a star of David, a menorah, a shofar, the Ten Commandments, Seder plates, and a rabbi flanked by ritual clothing and two Torahs. In *Obedient Unto Death, Even Death on the Cross*, we see a candle lighter/sniffer, two Bibles, two pink blossoms, a cross, the Holy Spirit represented as a white bird, two Communion wafers, two water pitchers suggestive of those that Mary Magdalene used to wash Jesus' feet, and a priest flanked by vestments.

Yet Grant includes both historical and contemporary references in several non-Biblical panels, such as one labeled "Daniel in the Lion's Den," a work that depicts the Canadian and British liberation of Nazi concentration camps in April, 1945. In this work, a German guard shouts an expletive when his gun fails to discharge at a gay prisoner who is standing on the hood of a jeep adorned with the Canadian flag. This scene, as Grant explained to me, honors Leopold Engleitner, once believed to be the oldest surviving male concentration camp survivor, who passed away in May, 2013, at age 107.

EASTER'S BEST

Grant's exploration of religion continues in *Easter's Best*, a suite of five drawings made with colored pencil and ink on watercolor paper

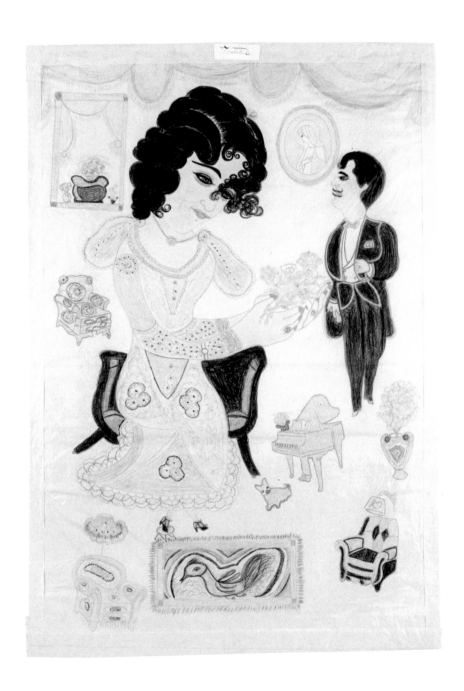

FIG. 1
Mary Bell, *Gratitude*, n.d. (before 1938)

in which Grant depicts Christian figures, one per work, in Bell's signature style. Each subject (two men, three women, all haloed) is depicted full-length, frontal, and vividly colored, and each fills the composition from top to bottom. The figures stand above captions of their names, which are similar to the rectangular labels that Bell affixed to her drawings on tissue paper.

The men, both wearing suits and ties and sporting dark, curly hair and beards, are identified as *Yeshua/Jesus* and *John The Disciple of Jesus*. The palette of *Yeshua/Jesus* is the most limited of the five works. The halo and caption are golden and Jesus's suit is white. Jesus addresses his viewers with his mouth open and arms outstretched, his open palms displaying stigmata. In contrast, John appears as a dandy in a green suit with red trim, and is bordered by red chalices bearing coiled green serpents. With his head in profile and his left hand resting on his abdomen, John looks much like a suitor from a courtship scene drawn by Bell (*Gratitude*, c. 1936–39 [FIG. 1]).

The three women are the three Marys present at the Crucifixion. Smiling, all sport short, wavy black hair, purple eye shadow, necklaces, red fingernails, elaborate shin-length gowns featuring Matisse's palm leaves, colored stockings, and pumps. The Mary of *Mary Mother of God* is flanked by large white Easter lilies and reaches for a small, lidded chalice. *Mary of Clopas* (mentioned only in John 19:25) was Jesus's aunt on his mother's side. Her supporting role is suggested by the large coffeepots to either side of her. *Mary Magdalene* is in turn flanked by two corked olive oil jars and, with her hands-on-hips stance, swirling dress, striped hose, and rakish scarlet hat, she is the most dramatic of the three women. Grant adapted Mary Magdalene's confident pose and flair from the central figure (the most light-skinned one) in Bell's *American Mixtures of the Ethiopian Race* (c. 1936–39) [FIG. 2]. Part of Grant's attraction to Bell was the latter's Catholicism, which is evident in her letters to Carl Van Vechten and her drawings which occasionally featured the Virgin Mary. In evoking Bell's style, Grant pays homage to the artists' shared religious and cultural identities, and in these drawings, she infuses the Easter celebration with an individualized vitality.

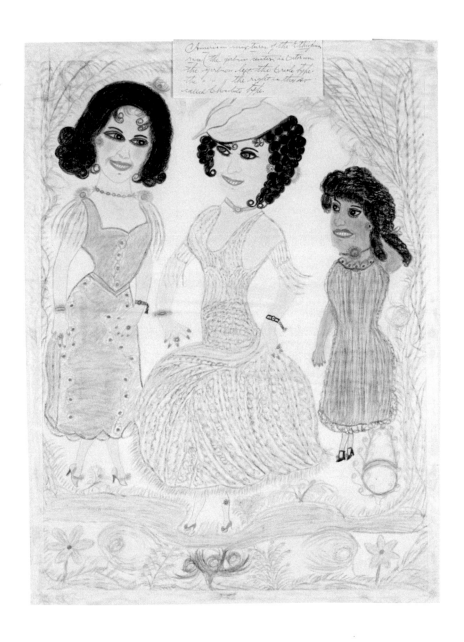

FIG. 2
Mary Bell, *American Mixture of Ethiopian Race*, n.d. (before 1938)

Grant's work invites us to meander through her story concepts and appropriations, which she insists, as deliberate free associations, have no connective meaning. She declares that if her compositions "were all so structured and blueprinted, [she] might as well be an architect."[5] Grant's audience is left alone to consider how elements in her work interact or cancel each other out. Yet Grant does offer a hybrid of autobiographical memory and fictionalized history, all in her distinctively dense, all-over style. If we match Grant's slow tempo of creation with patience and an immersive attention,[6] we are rewarded with a wealth of detail and allusion that takes time to perceive.

5 Interview with Grant in her Harlem studio (August 23, 2013).
6 From Jennifer Roberts, "The Power of Patience," *Harvard Magazine* (Nov.-Dec., 2013): n.p. http://harvardmagazine.com/2013/11/the-power-of-patience. Accessed Oct. 20. 2013.

Crowning the Lion and the Lamb

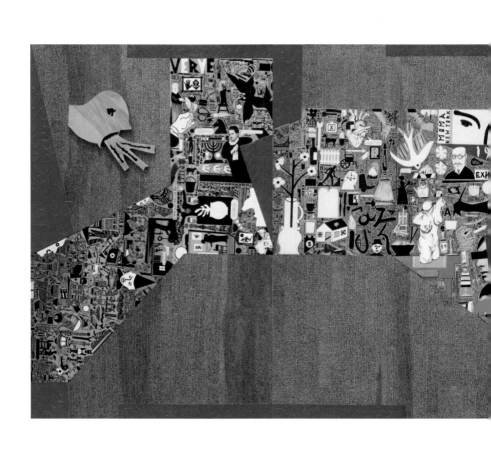

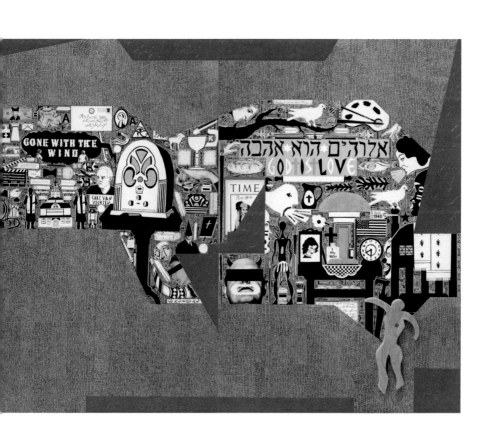

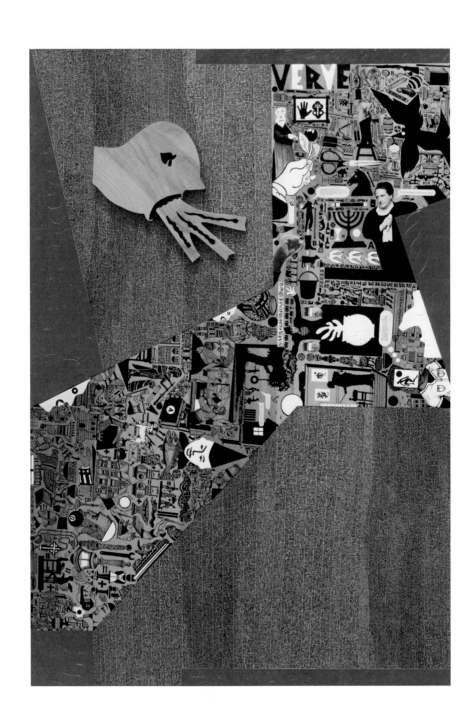

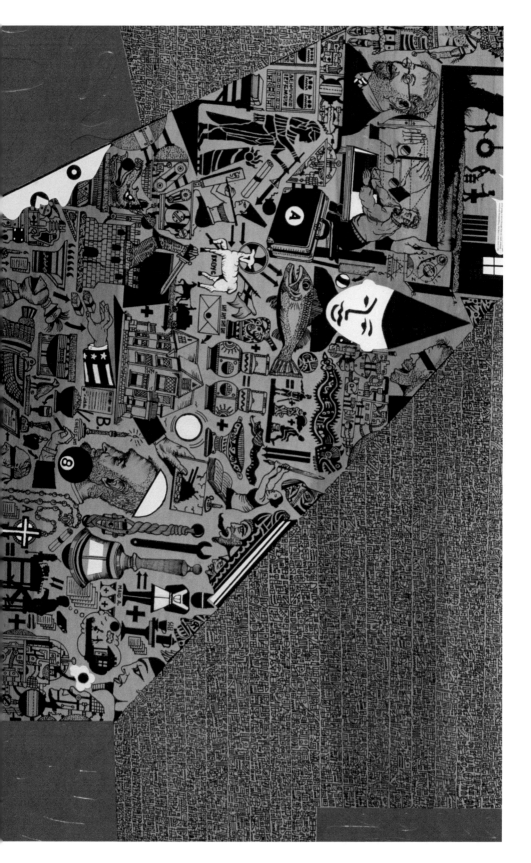

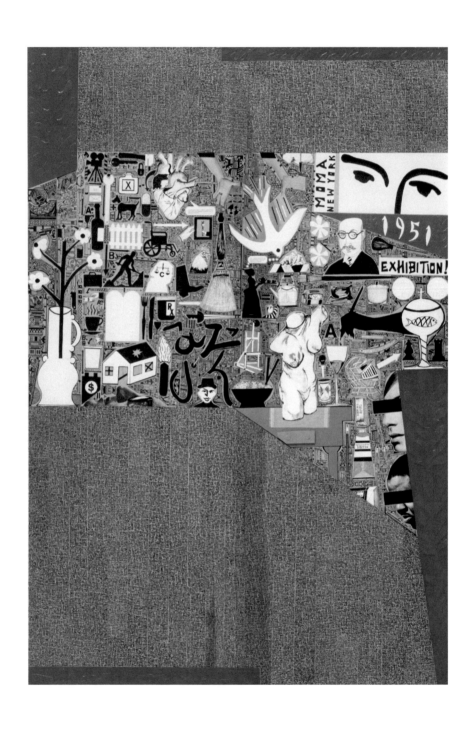

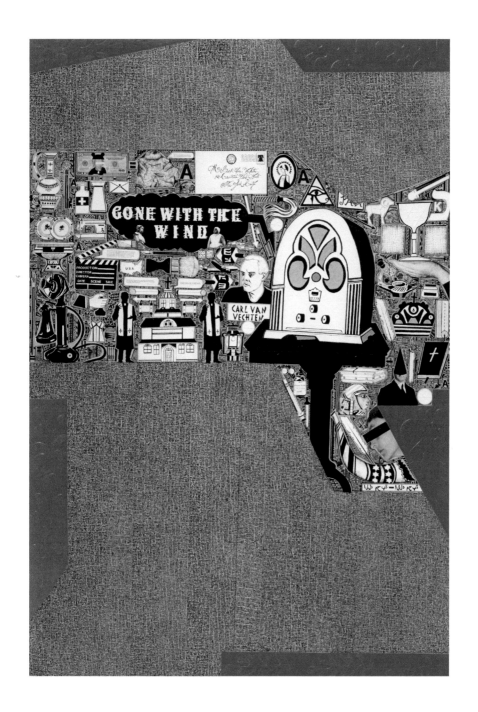

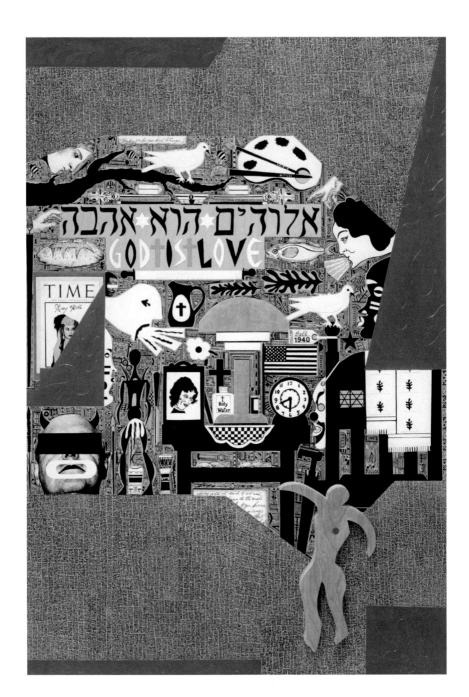

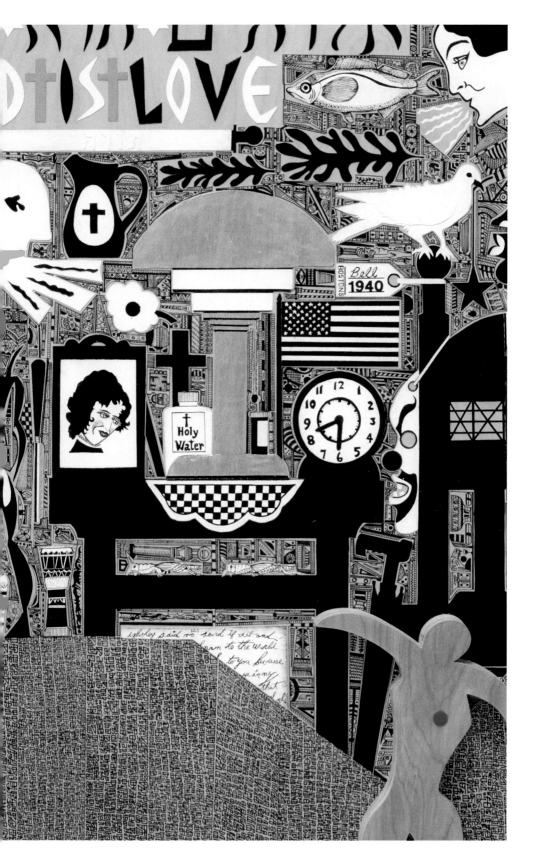

God's Voice in the Midnight Hours

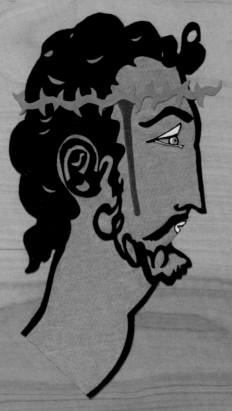

YESHUA

THE CRUCIFIXION

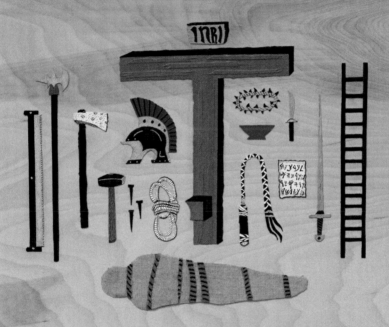

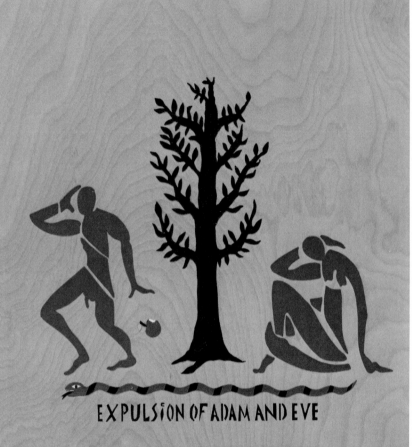

EXPULSION OF ADAM AND EVE

THE PASSOVER SEDER AND SACRIFICE

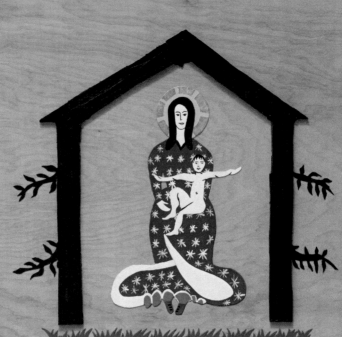

MADONNA AND CHILD

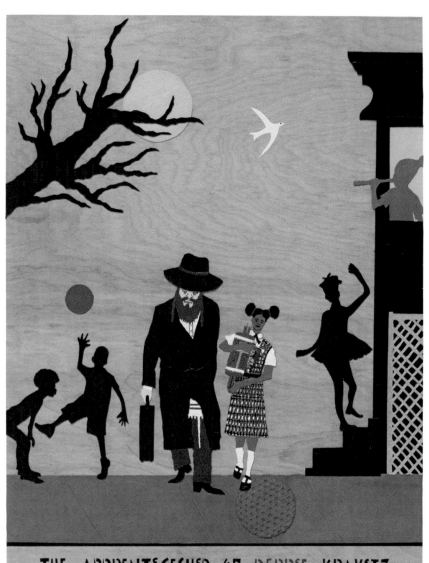

THE APPRENTICESHIP OF DEBBIE KRAVITZ

NOAH

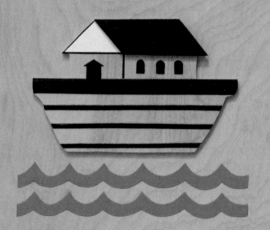

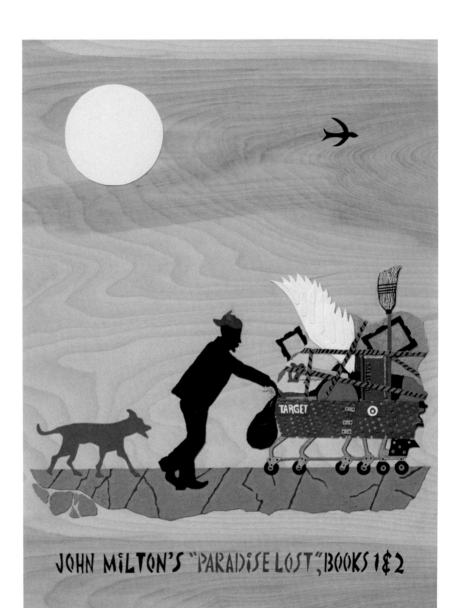

JOHN MILTON'S "PARADISE LOST", BOOKS 1 & 2

EAST OF EDEN

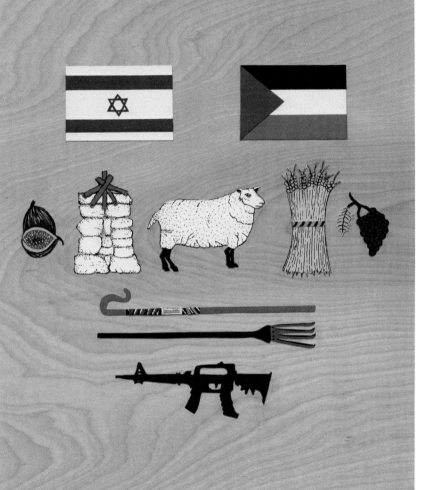

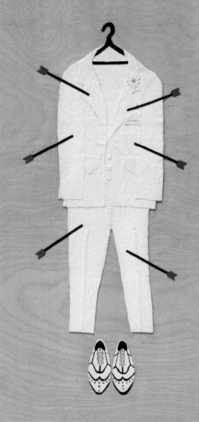

ST. SEBASTIAN VENABLE

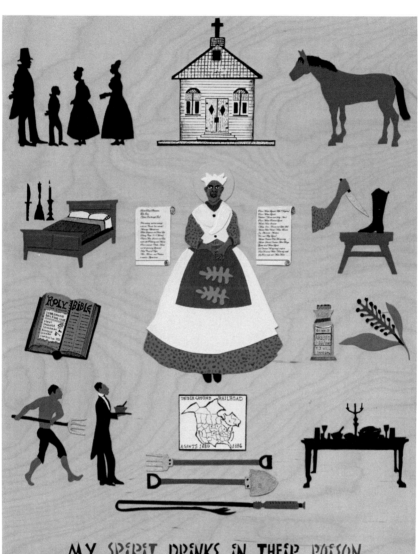

MY SPIRIT DRINKS IN THEIR POISON

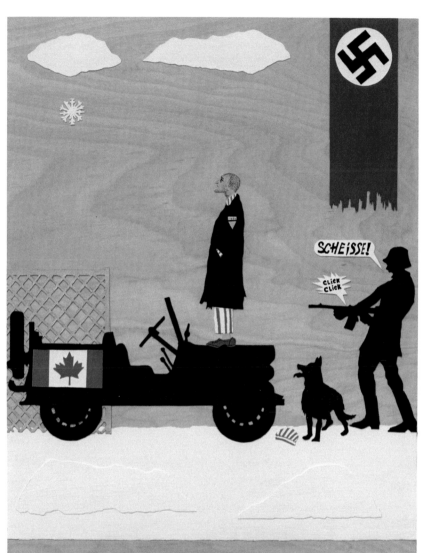

דניאל בגוב האריות/DANIEL IN THE LION'S DEN

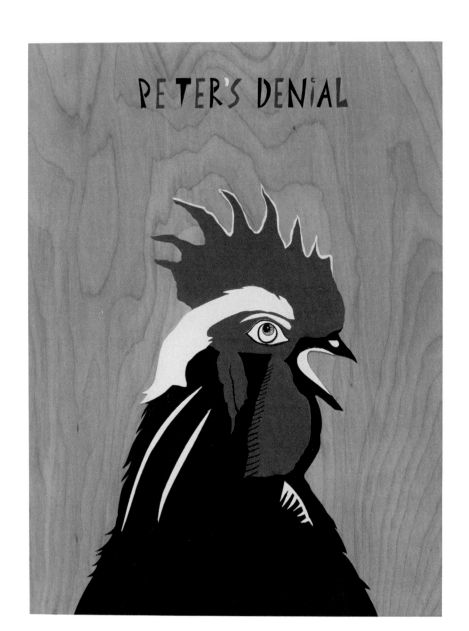

PETER'S DENIAL

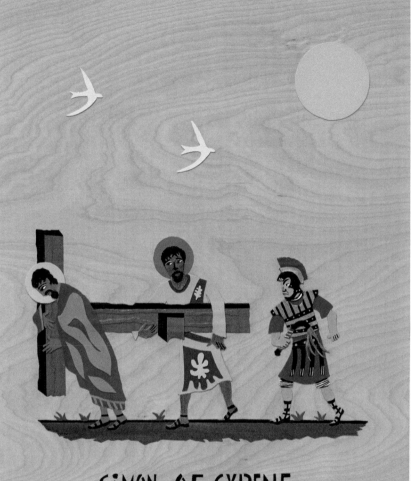

SIMON OF CYRENE

THE BLOOD OF LAMBS

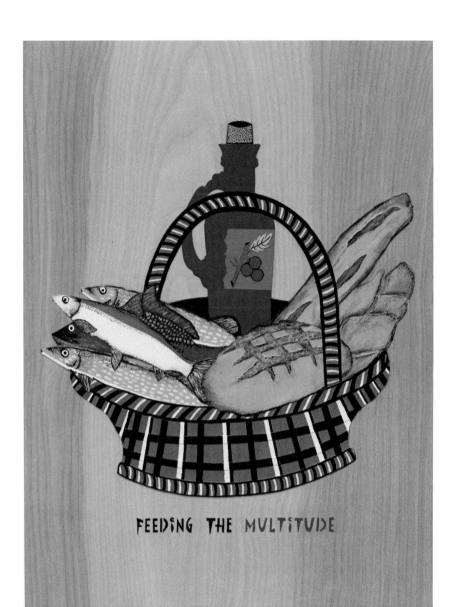

FEEDING THE MULTITUDE

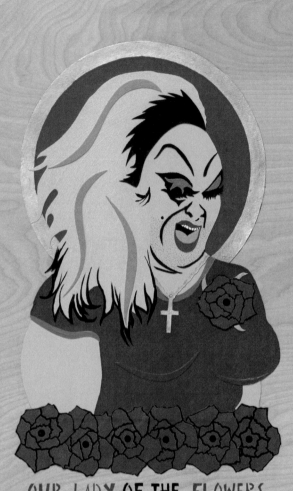

OUR LADY OF THE FLOWERS

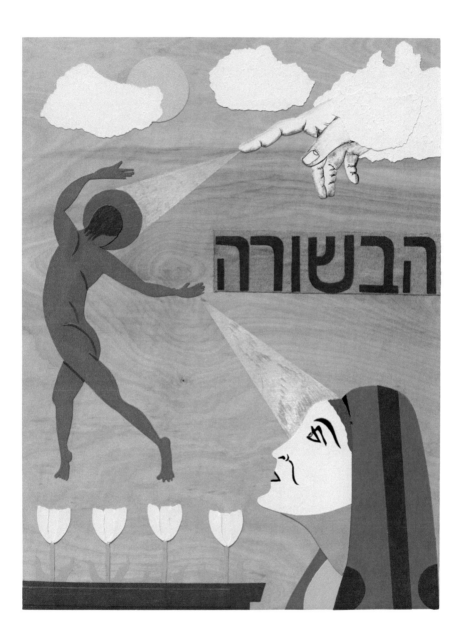

THE BODY AND BLOOD

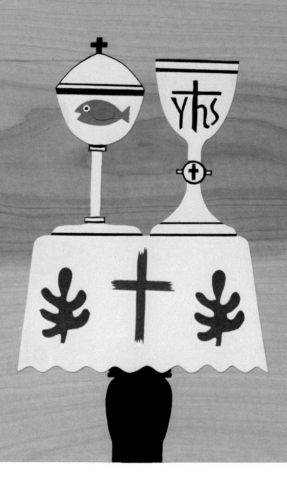

SCHIZOPHRENIC'S BELIEF IN THE BURNING BUSH

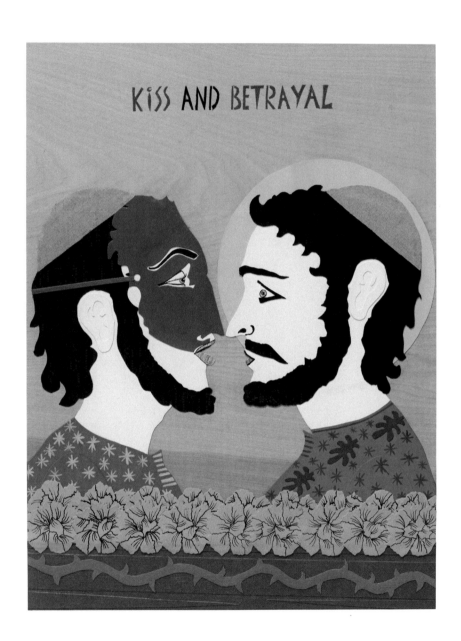

PiLATE WASHES HiS HANDS

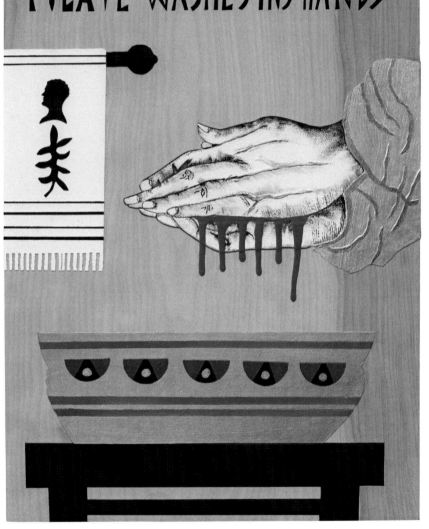

Obedient Unto Death, Even Death on a Cross
Hosanna to the Son Of David

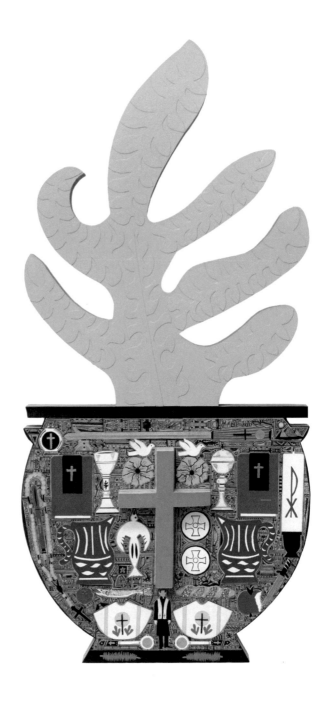

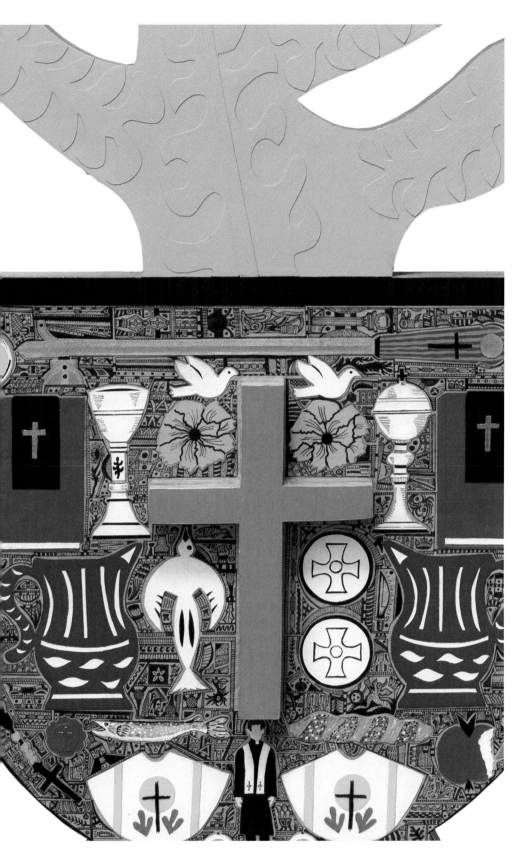

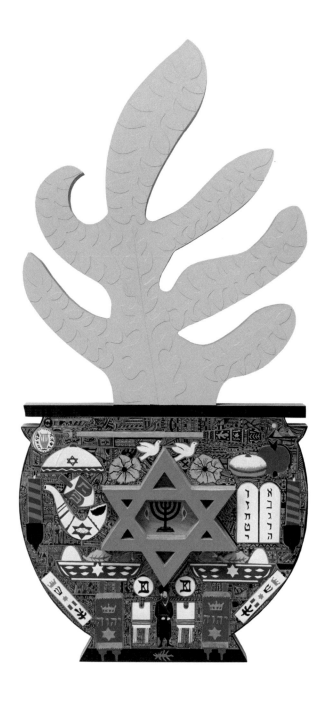

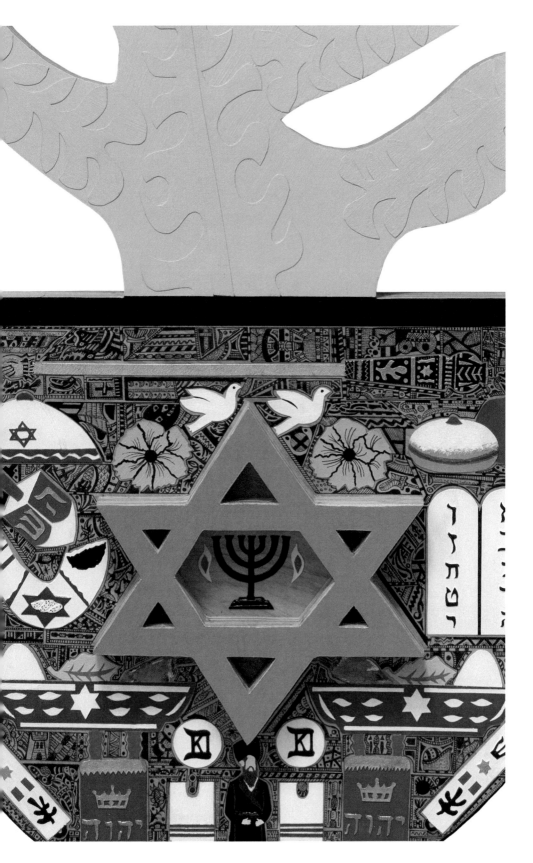

Easter's Best

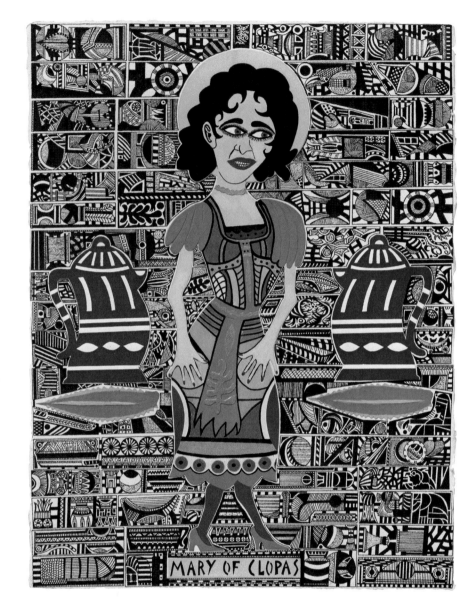

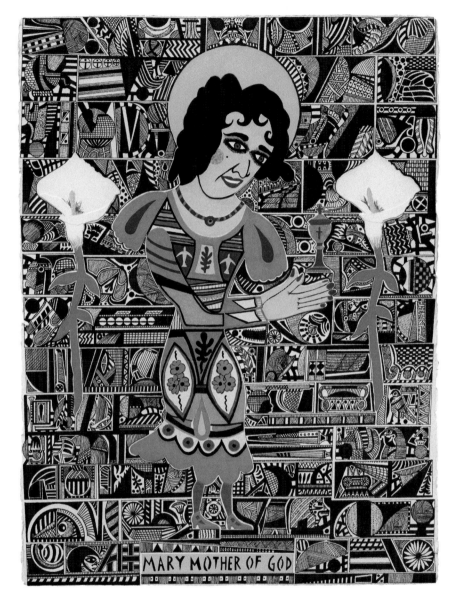

MARY MOTHER OF GOD

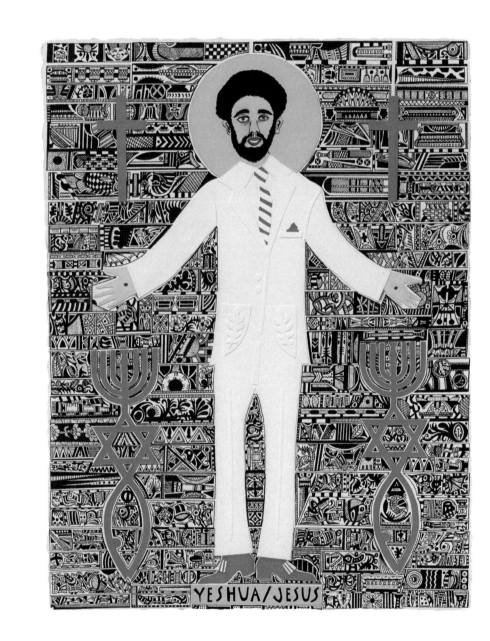

YESHUA/JESUS

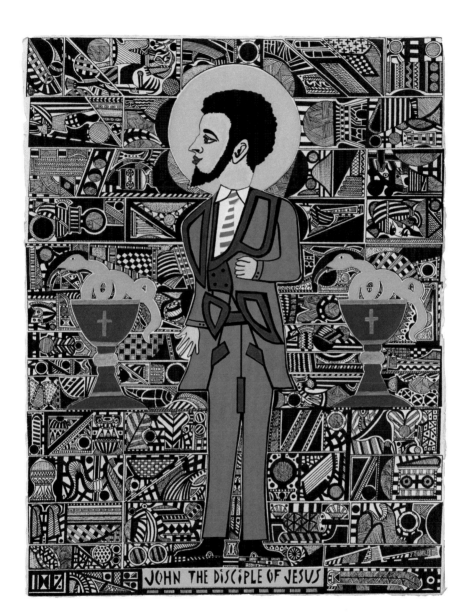

JOHN THE DISCIPLE OF JESUS

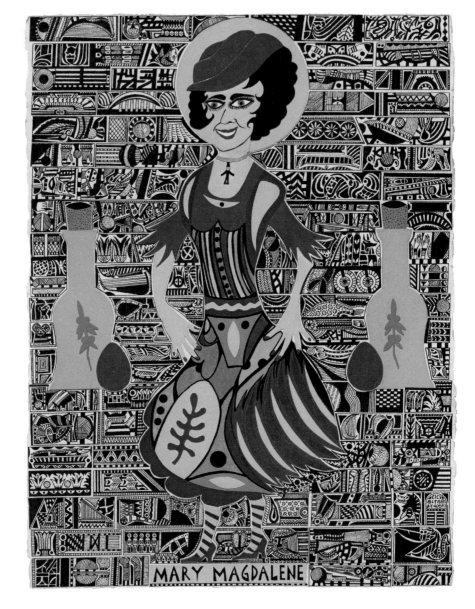

MARY MAGDALENE

Deborah Grant
Crowning the Lion and the Lamb, 2013
Oil, acrylic, enamel, paper, Arches W.C. paper,
and birch wood on Baltic birch panel
Four panels, each: 72 x 48 x 2 inches
(183 x 22 x 5 cm); overall: 72 x 192 x 2 inches
(183 x 487.7 x 5 cm)

Deborah Grant
God's Voice in the Midnight Hours, 2013
Oil, acrylic, enamel, paper, Arches W.C. paper,
linen, and birch wood on Baltic birch panel
Twenty-four panels, each: 24 x 18 x 1 1/2 inches
(61 x 46 x 3.8 cm)

Deborah Grant
Obedient Unto Death, Even Death on a Cross, 2013
Oil, acrylic, enamel, Arches W.C. paper,
and birch wood on Baltic birch panel
50 x 23 x 2 inches (127 x 58.4 x 5 cm)

Deborah Grant
Hosanna to the Son Of David, 2013
Oil, acrylic, enamel, Arches W.C. paper,
and birch wood on Baltic birch panel
50 x 23 x 2 inches (127 x 58.4 x 5 cm)

Deborah Grant
Easter's Best, 2013
Acrylic, archival ink, colored pencil, and Arches
W.C. paper mounted to Arches W.C. paper
Five drawings, each: 22 x 30 inches
(55.9 x 76.2 cm)

All works courtesy of the artist and
Steve Turner Contemporary, Los Angeles.

FIG. 1
Mary Bell
Gratitude, n.d. (before 1938)
Crayon on paper
30 7/10 x 20 3/10 inches (78 x 51.5 cm)
Image courtesy of the Yale Collection
of American Literature,
Beinecke Rare Book and Manuscript Library,
Carl Van Vechten Papers

FIG. 2
Mary Bell
American Mixture of Ethiopian Race, n.d.
(before 1938)
Crayon on paper
20 1/2 x 15 1/2 inches (52.1 x 39.4 cm)
Image courtesy of the Yale Collection
of American Literature,
Beinecke Rare Book and Manuscript Library,
Carl Van Vechten Papers

Claire Gilman is curator at The Drawing Center.

Dr. Theresa Leininger-Miller is Associate Professor of Art History and former Director of Graduate Studies in Art History at the University of Cincinnati. She is the author of *New Negro Artists in Paris: African American Painters and Sculptors in the City of Light, 1922–1934* (Rutgers, 2001) and has published essays in the anthologies *Common Hopes, Common Sorrows: Women of the Harlem Renaissance* (University Press of Mississippi, 2014), *The Modern Woman Revisited: Paris Between the Wars* (Rutgers, 2003), and *Out of Context: American Artists Abroad* (Praeger, 2004). Dr. Leininger-Miller has also authored essays for the exhibition catalogues *The Harlem Renaissance* (Oklahoma City Museum of Art, 2009), *Paris Black* (Wuppertal, Germany: Peter Hammer Verlag, 2006), and *Paris Connections: African-American Artists in Paris* (San Francisco: Bomani Gallery and Jernigan Wicker Fine Arts, 1992), as well as for multiple refereed journals, reference guides, and auction catalogues. She has curated exhibitions on Civil War-era illustrated sheet music by black composers, nineteenth-century Cincinnati, the Tyler Davidson Fountain of 1871, and on Mary Bell. She is currently working on her second book, *Sculpting the New Negro: The Life and Art of Augusta Savage*, with support from the National Endowment for the Humanities and a Scholarship in American Modernism from the Georgia O'Keeffe Museum Research Center.

ACKNOWLEDGMENTS

Deborah Grant: Christ You Know it Ain't Easy!!
is made possible in part by Steve Turner and
Victoria Dailey, Monroe Denton, Dee and Gianna
Kerrison, and Jeanne Greenberg Rohatyn.

EDWARD HALLAM TUCK PUBLICATION PROGRAM

This is number 111 of the *Drawing Papers*, a series of publications documenting The Drawing Center's exhibitions and public programs and providing a forum for the study of drawing.

Jonathan T.D. Neil *Executive Editor*
Joanna Ahlberg *Managing Editor*
Designed by Peter J. Ahlberg / AHL&CO

This book is set in Adobe Garamond Pro and Berthold Akzidenz Grotesk. It was printed by BookMobile in Minneapolis, Minnesota.

TO ORDER, AND FOR A COMPLETE CATALOGUE OF PAST EDITIONS,
VISIT DRAWINGCENTER.ORG

THE
DRAWING
CENTER

35 WOOSTER STREET | NEW YORK, NY 10013
T 212 219 2166 | F 212 966 2976 | DRAWINGCENTER.ORG